Hieronymus Bosch

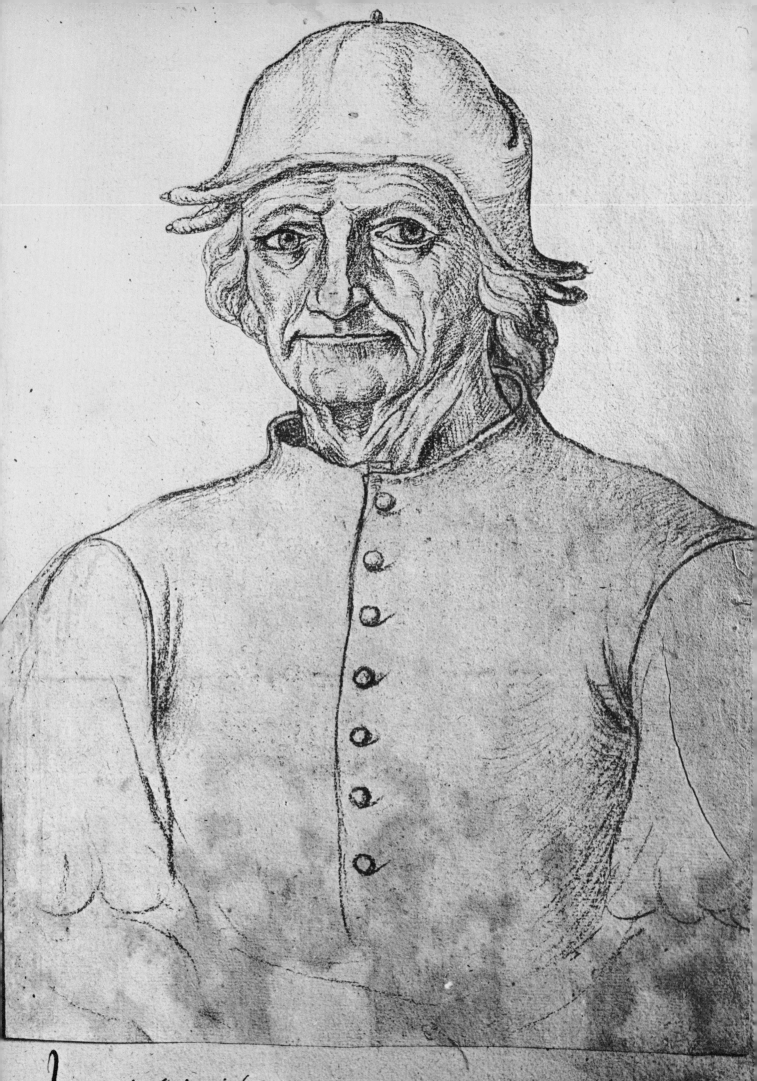

Jeronimus Bos painter

THE COMPLETE DRAWINGS OF

Hieronymus Bosch

Charles van Beuningen

Academy Editions • London

St. Martin's Press • New York

We would like to thank the museums that have given us permission to reproduce pictures from their collections: The National Gallery of Art, Washington D.C.; Musée du Louvre, Paris; The British Museum, London; Museum Boymans-van Beuningen, Rotterdam; Kupferstichkabinett, Berlin; Albertina, Vienna; Bibliothèque Royale Albert 1er (Cabinet des Estampes), Brussels; Ashmolean Museum, Oxford; Museo del Prado, Madrid; Alte Pinakothek, Munich; Musée des Beaux-arts, Lille; Bibliothèque de la Ville d'Arras; Akademie der Bildenden Künste, Vienna; Pierpont Morgan Library, New York; Kupferstichkabinett, Dresden.

Frontispiece: Portrait of Hieronymus Bosch in the Codex of the Bibliothèque de la Ville d'Arras, known as the *Receuil d'Arras*. (Photo Giraudon)

Dec 1973

First published in Great Britain in 1973 by Academy Editions, 7 Holland Street, London W.8.

First published in The United States of America in 1973 by St. Martin's Press Inc., 175 Fifth Avenue, New York, N.Y. 10010. Affiliated publishers: Macmillan Company Ltd., London - also at Bombay, Calcutta, Madras and Melbourne - The Macmillan Company of Canada Ltd., Toronto.

Designed by Prantong Jitasiri.
Printed by Burgess & Son (Abingdon) Ltd., and bound in Great Britain at The Pitman Press, Bath.
SBN 85670 092 4 cloth. 85670 097 5 paper.

Introduction

So little is known of the life of Hieronymus Bosch that we must be resigned to an ambiguity in any interpretation of his work. The unstable moral and religious climate of the late middle ages compounds this lack of historical information, leaving us certain only of his status as an isolated figure who evolved an unprecedented vision independent of any contemporary artistic movement. Because he developed a style apart, comparisons with contemporary artists do not contribute significantly to an understanding of his strange and difficult paintings. The only analysis possible is one grounded on the body of work itself, in which a definite evolution of style, painterly technique and iconography has recently been discovered. Such a study, when coupled with the available biographical and historical information, has made these puzzling paintings more accessible, giving us a perspective on the artist in relation to his society and allowing for, in some cases, an interpretation of his symbols and a definitive chronology.

Bosch was born c. 1450 in 's-Hertogenbosch in Northern Brabant and, as far as we know, spent all of his life in this isolated provincial town. 's-Hertogenbosch shared in the general state of economic prosperity enjoyed by the Netherlands in the 15th century and here, as everywhere, cultivated burghers thrived on the growing success of trade and industry. Intellectually and culturally speaking it was an insignificant town, removed from the vital centres of Tournai, Burges, Antwerp, Brussels, Ghent, Louvain, Delft and Haarlem, and largely untouched by the continuing development of the discoveries made by painters like Jan and Hubrecht van Eyck some fifty years before. In this unlikely setting Bosch began to paint c. 1480, choosing to sign his work with the last syllable of the name of his town, a name that brings to mind Dante's symbolic wood of philosophical complexities and confusions. His family history is poorly documented, though it is known that his family name was van Aken, which has led scholars to believe that his ancestors emigrated from Aix-la-Chapelle, 'Aaken' in Dutch. The first van Aken appeared in the records of the Cathedral of St. John in 's-Hertogenbosch in 1399, when Jan van Aken, a furrier, acquired citizenship. His death in 1418 is recorded and from 1423-1434 the name of another Jan van Aken, a painter and presumably Bosch's grandfather, is mentioned several times. The name reappeared in 1464, this time probably in reference to Bosch's father. The death of Bosch himself was recorded there in 1516, as was his membership in the Brotherhood of Our Lady, the local religious confraternity, and his marriage to Aleyt van de Meervenne, a wealthy woman whose dowry brought Bosch some land at the nearby village of Oirschot. It can be assumed that the financial independence Bosch attained through marriage gave him the opportunity to freely develop his own independent intellectual and moral system un-

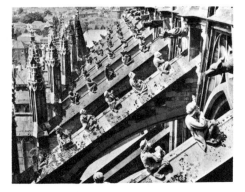

The Cathedral of St. John, 'sHertogenbosch.
The decorated flying buttresses and a detail.

hindered by the expectations and desires of patrons. No-one knows if Bosch travelled, if he knew any other artists or what paintings he might have seen. This makes it difficult to judge the exact extent of his originality, but that he was profoundly so is indisputable, as is his influence on the artists that followed him.

In the 15th century Dutch and Flemish artists worked in a traditional master-pupil relationship, within schools clearly defined on either a geographical or studio basis, a practice evidenced by the consistent style and recognisable characteristics of paintings belonging to, for example, the Haarlem or Delft schools. Bosch, who did not fit into any of these well-established patterns, baffled the first art historians who studied his work. They found what seemed to be an impossible confusion of mediaeval archaisms and advanced, totally original conceptions, combining to produce an art that, while heralding the great Dutch school of the 17th century with its worldly subject matter, in other ways hearkened back to the devotional paintings of the early middle ages.

In their search for possible influences on Bosch historians first looked to the works of art that existed in 's-Hertogenbosch. The town possessed the finest example of Gothic architecture in the Netherlands in the Cathedral of St. John, an unusual building in a country where almost all churches were made of brick. Four frescoes, dating from the early 14th to the 15th century, decorated the pillars of the choir the most recent of which, painted in 1444 by Jan van Aken, presumably Bosch's grandfather, bears a clear resemblance to one of Bosch's early paintings, *The Crucifixion.* Certain other features of the building have been cited as probable influences, notably the gargoyles that squat along the buttresses. In the further construction on the cathedral that was undertaken between 1480 and 1500 the completion of the south wing of the transept and the beginning of the central wing was supervised by Alaart de Hameel, who did engravings after Bosch's works (see pp. 82, 83).

Another but this time literary source of Bosch's demoniacal iconography may have been the Dutch version of the *Visio Tundali,* printed in 's-Hertogenbosch towards the end of the 15th century. The book charts Tundal's journey through Hell, Purgatory and Paradise, describing his encounters with monsters, serpents, fantastic animals and the subtle tortures inflicted on doomed souls. The popular poem *The Ship of Fools,* written by Sebastian Brant and published in Basle in 1494, is often cited as the origin of Bosch's ironic painting of that name, in which a group of revellers in a boat are floating unawares to the doom of a fool's paradise.

The most recent development in Bosch studies has been an

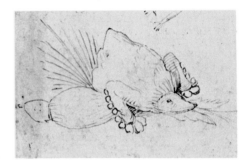

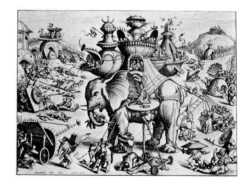

A Beleagured Elephant. *Museum Boymans-van Beuningen, Rotterdam.*
40.2 cm. x 54 cm. (15¾" x 13¼").
This version of a lost work by Bosch differs slightly from the engraving by Allaart de Hameel (see page 83).

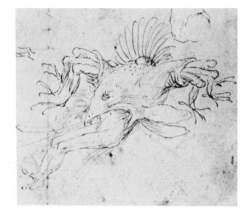

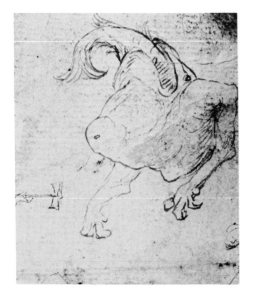

investigation of his iconography in terms of the spiritual fabric of the late middle ages. From a purely artistic point of view Bosch did, in effect, spring out of nowhere, painting as no-one had painted before, but what he had painted was deeply rooted in widespread and vitally important cultural conditions. Far from being the product of his individual fantasies, his was an indigenous art, springing from a constellation of widely understood symbols and accepted ideas. Long categorized as a heretic by historians, Bosch was considered a profoundly religious man during his lifetime. Historians have now reverted to the contemporary view, with a deeper understanding of the conflicting forces that affected religion at the time.

During the late middle ages the populace was obsessed with fear of Anti-Christ, whose arrival was believed to be imminent. Apocalyptic sermons, part of the late Netherlandish mystical tradition, were delivered, in which evil and other moral abstractions were concretized as monsters, demons and animals. The established church, in their dread of Anti-Christ, saw the age-old practices of witchcraft, magic and alchemy as a greater threat than ever before and in 1484 the Papal Bull *Summis Desiderates* launched a campaign of persecution against the practitioners of such rituals. How familiar Bosch was with the witchcraft cannot be known, but certainly the symbolic religious vernacular was alive to him, though it was actually in the process of change and disappearance.

Although today it is not possible to establish the exact connotations of the images he used, that once he was working within a readily accessible convention is proven by the admiration given to Bosch in his lifetime, even by such orthodox believers as Philip II of Spain, who purchased many of his finest paintings for the Escorial.

Bosch's involvement with the Brotherhood of Our Lady is essential to an understanding of his independent attitude to religion. The Brotherhood, associated with the Cathedral of St. John, was founded in 1318 and exists to this day. It allowed the membership of laymen from its inception, when it was exclusively concerned with religious tasks and the veneration of the Mother of God. In the 15th century they broadened the scope of their activities, performing charitable acts in accordance with their new philosophy of pious action within the world, a change of attitude influenced by the Brethren of the Common Life, who in 1424 came to 's-Hertogenbosch, where they called themselves Hieronymites. As other brotherhoods in the Netherlands had been doing since the late 14th century the Hieronymites preached a renewal of spiritual life. Geert Groote, a preacher, initiated the movement primarily as a protest against the corruption of the clergy and as an

attempt to revitalize religion on a more pious and pure basis. Believing salvation could be achieved without the intermediary of the official church they saw themselves as brothers united in a true religion, distinct from the "false brothers" who cut themselves off from the world in pointless monastic seclusion. Their philosophy of asceticism within the world anticipated the Reformation but Bosch, though very sympathetic to their ideas, was still bound to the Catholic concept of mortification and does not seem to have been fully absorbed into either the old or new religion. His depictions of sin in the context of everyday life reflect the attitudes of the Brotherhood and his critical portrayals of the world around him mark a break from the purely devotional, conventional art of the middle ages. He painted man not according to spiritual formulae but in his reality, as a being who possesses free will, confronted by the dilemma of choice or blinded, by choice, to his own sin and folly. By depicting a human soul that was not passive his art demanded an intellectual and active response.

He grasped the forces that motivate the independent soul, and explored the unconscious without the prescriptions of religious doctrines, paving the way for the secular, psychological painters that followed him. Bosch's man is suspended in the dilemma that confronted society and in the unresolved confusion and uncertainty that plagued it. As J. De Siguenza wrote in 1605 in his *Tercera Parte de la Historia de la Orden de San Geronimo:* "The difference which in my opinion exists between the paintings of this man and those of others consists in that the latter seek to paint men as they outwardly appear, whereas he has the courage to paint them as they are inwardly."

Apart from attempting to place the work of Bosch in a historical context and understand its symbolism, historians have always been faced with the difficult task of organizing the paintings chronologically. None of them are dated, gaps have been left by the disappearance of others and several have been reworked by later hands. A division into three basic groupings - the youthful, the mature and the final periods - has long been accepted, but the designation of specific pictures into these categories was questionable and has only recently been resolved anew.

It was originally assumed that as Bosch matured he turned gradually away from religious 'mediaeval' themes to a greater realism. His work would then be assigned to a sequence that parallels the change of attitude in society, making *The Garden of Earthly Delights* an early work and pictures like *The Hay Wain* the triumph of his old age. Research in the last forty years has focused on painterly and stylistic qualities, hoping to discover a more consistent and satisfactory progression. This analysis has resulted in

HIERONYMUS BOSCH

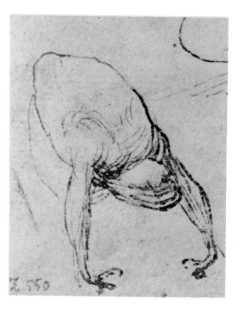

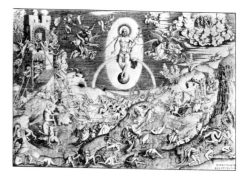

The Last Judgement. *Museum Boymans-van Beuningen, Rotterdam.*
This engraved copy of a lost work by Bosch is generally considered to be by van der Hayden or Galle, although Lehrs attributed it to Allaart de Hameel. (See page 83)

8

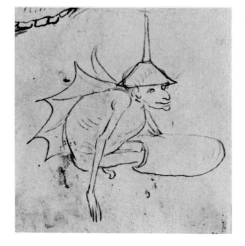

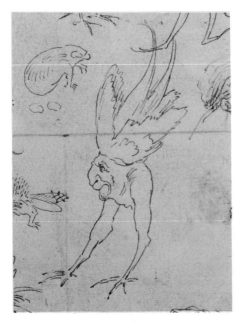

a revised sequence in which six paintings have been assigned to the first period because of a stiffness and angularity of draperies, bright unmodulated colours (as opposed to the deep van Eyckian ones used later), an incoherent relationship between the figures and the landscape, unsophisticated symbolism and an uncertainty of brushwork. The great triptychs are now assigned to his second or middle period, when his unique style emerged, capable of conveying universal ideas and freed from the last elements of tradition that bound it. During his final period, covering the last six-eight years of his life, Bosch seems to have looked, for the first time, back to the masters of the early Renaissance like van Eyck and the Master of Flemalle, in his desire to achieve a grand consummate style. In his last great paintings, though consistent in style with his earlier works, an even greater precision is achieved and a more personal feeling is allowed to emerge.

In his drawings Bosch broke with the traditional Dutch medium of silver point, which allowed the artist to depict volume, light and shade through infinitely fine hatchings. Using the pen almost exclusively, Bosch developed a new and more expressive technique. Those drawings which correspond to his first period in painting are composed mainly of straight lines. In the second period a bold line emerges, full of free, assured curves which he combines, in his last drawings, with a synthesis of heavy hatching and gentle dashes.

Only about 40 sheets of drawings have survived, enough to give us an idea of his use of the medium but too few for the kind of minute stylistic analysis possible with his paintings. They can be broken down into three categories on the basis of theme rather than chronology - studies and designs for paintings, sheets of experimental variations on a chosen theme and those which are complete and so beautifully composed as to stand on their own as works of art, some of them achieving a boldness not surpassed in his paintings. As the first Dutch artist to employ the pen as a means of personal expression he began a tradition, furthered by Brueghel and Rembrandt, that has made drawing the significant medium it is considered to be today.

During the 16th and the first half of the 17th centuries the paintings of Bosch influenced many artists throughout Europe. The Flemish painters Pieter Brueghel the Elder and Reubens confirmed his secular vision and Rembrandt explored the psychological element he had introduced. But by the end of the 17th century Bosch's fame had waned and he did not regain popularity until the end of the 19th century, when he was studied again and his genius reconfirmed. The Surrealists were largely responsible for the renewal of interest in Bosch in this century. They hailed

him as the major pre-Surrealist visionary, their greatest forerunner, dubbing him, along with Archimboldi, Caspar David Friedrich and others as "a Surrealist despite himself". *The Garden of Earthly Delights, The Haywain* and *The Temptation of St. Anthony* were seen as realizations of André Breton's definition of Surrealist works of art as those "based on the belief in the superior reality of certain forms of association heretofore neglected, in the omnipotence of dreams and the disinterested play of thought". Dreamlike atmospheres and illogical juxtapositions of objects are common to Surrealist painting and offsprings of Bosch's hybrid creatures can be found, for example, in the work of Max Ernst. René Magritte, on the other hand, found the comparison between Bosch and Surrealism "facile and false", recognizing that a basic difference must separate them, since Bosch's language sprung from and referred directly to specific, accepted nameable ideas. Magritte called Bosch "a 'religious realist' in the way that today there are 'social realists' ". Despite the historical truth of Magritte's remarks, the Surrealist adoption of Bosch and adaptation of his creatures and manner of composition has served to revitalize him for us by giving him a central place in the development of a major twentieth century movement. Freud's interpretation of dream symbolism and his discovery of the inner logic of seemingly disparate associations which accounts for so much of Surrealism itself has also allowed for a reappraisal of Bosch.

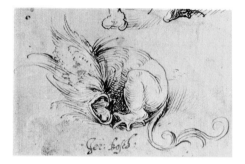

One of Bosch's greatest innovations, the open, flat landscape, was analogous to the openess of mind and unexplored possibilities of reason which were beginning to take precedence over the closed world of doctrine in the 15th century. For Bosch to have been considered as a father of irrational art is ironic yet perhaps inevitable, because of the mystery, 'surrealist by definition', which will always surround his work.

The catalogue numbers of the drawings are from Charles de Tolnay's Catalogue Raisonné, *Hieronymus Bosch*, Methuen and Co. Ltd., London, 1966. The text illustrations are details taken from various drawings by Bosch.

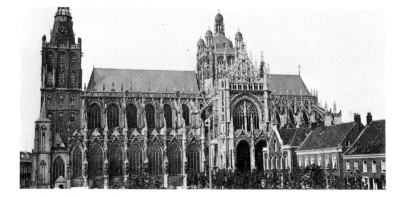

The Cathedral of St. John, 's-Hertogenbosch.

The Plates

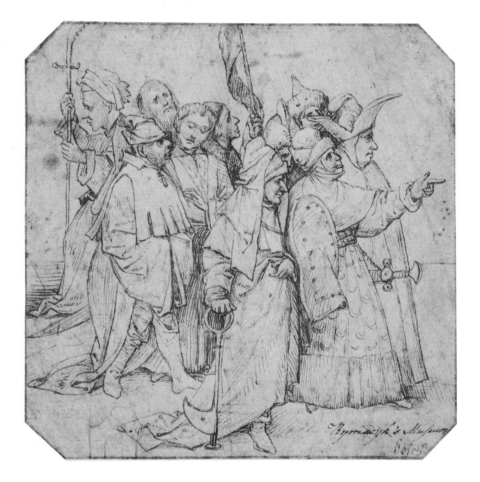

Group of Ten Spectators. *Pierpont Morgan Library, New York.*
Pen, 12.4 cm. x 12.6 cm. (4¾" x 5"). Catalogue No. 1
A youthful work from approximately the period of the *Ecce Homo* in the Städelsches Kunstinstitut in Frankfurt-on-Main.

The Entombment. *British Museum, London.*
Ink and grey wash over black chalk outline, 25 cm. x 35 cm. (9¾" x 13¾"). Catalogue No. 1a.
'Iheronimus Bosch' is faintly inscribed in black chalk on the front of the sarcophagus.

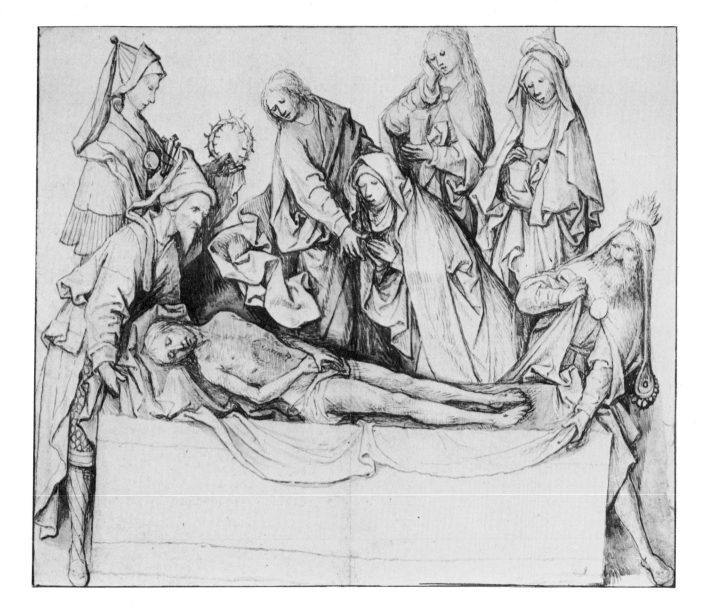

Two Witches. *Museum Boymans-van Beuningen, Rotterdam.*
Pen and bistre, 12 cm. x 8.5. cm. (4¾" x 3¼"). Catalogue No. 2.
This drawing is closely related to the drawings *Death and the Miser* and
The Ships of Fools. Signature apocryphal. On the reverse: *The Fox and
the Rooster.*

The Fox and the Rooster. *Museum Boymans-van Beuningen, Rotterdam.*
Pen and bistre, 12 cm. x 8.5 cm. (4¾" x 3¼"). Catalogue No. 2 verso.
On the reverse: *Two Witches.*

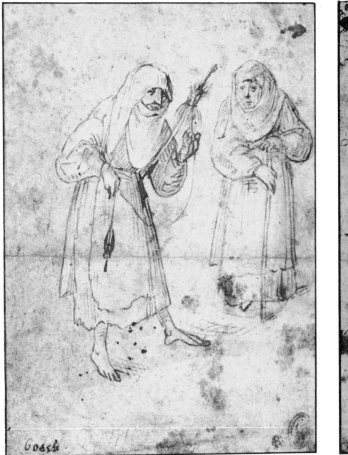

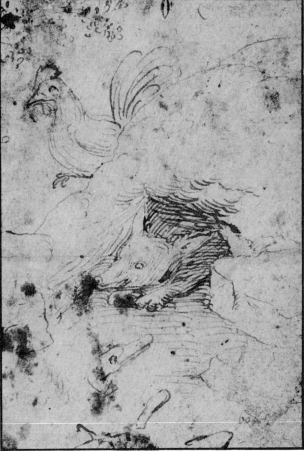

15

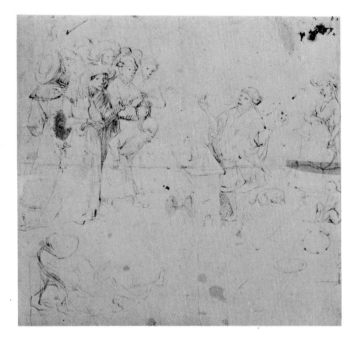

The Conjuror. *Musée du Louvre, Paris.*
Pen and bistre,27.8 cm. x 20.2 cm.(11" x 8"). Catalogue No. 3.
Preliminary study for the painting in the Louvre. On the reverse: *Burlesque Concert.*

Burlesque Concert. *Musée du Louvre, Paris.*
Pen and bistre, 27.8 cm. x 20. 2 cm. (11" x 8"). Catalogue No. 3 verso.
This drawing is not by Bosch. On the reverse: *The Conjuror.*

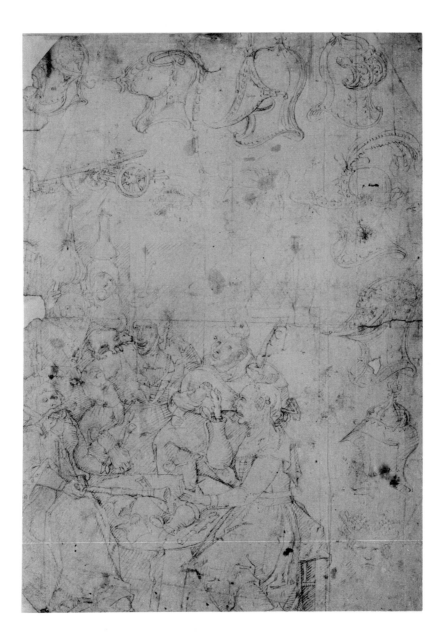

The Ship of Fools in Flames. *Akademie der Bildenden Künste, Vienna.*
Pen and bistre, 17.6 cm. x 15.3 cm. (6¾" x 6"). Catalogue No. 4.
This drawing is possibly a preliminary sketch for the right wing of a
triptych or diptych, the left wing of which might be *The Ship of Fools*
in the Louvre.

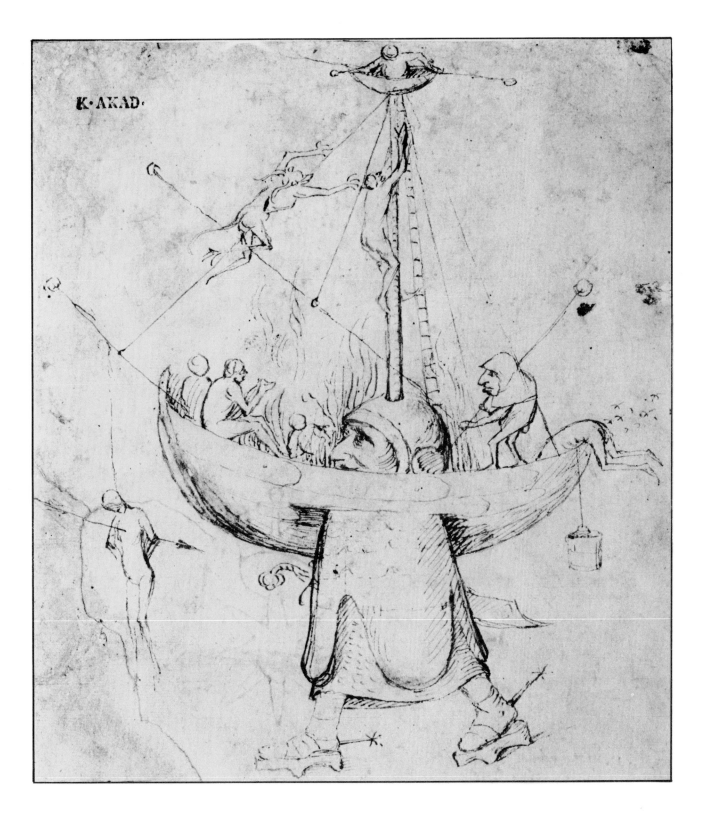

The Temptation of St. Anthony in a Landscape. *Kupferstichkabinett, Berlin.*
Pen and bistre, 25.7 cm. x 17.5 cm. (10" x 6¾"). Catalogue No. 5.
The monster with its body in the shape of an egg recurs, further developed, on the *Hell* panel of *The Garden of Earthly Delights*. The sheet has been repaired by paper pasted on the left and the middle. On the reverse: *Concert in an Egg.*

20

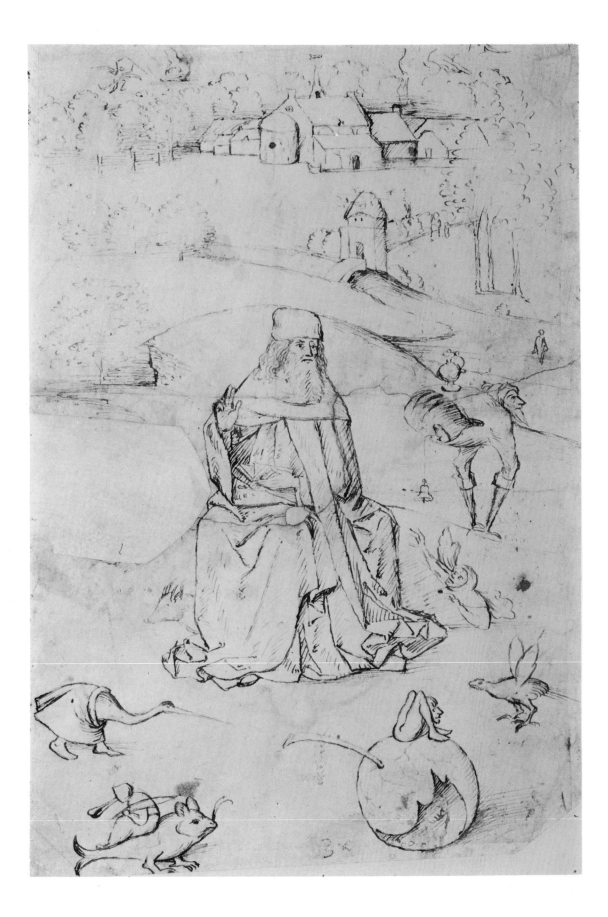

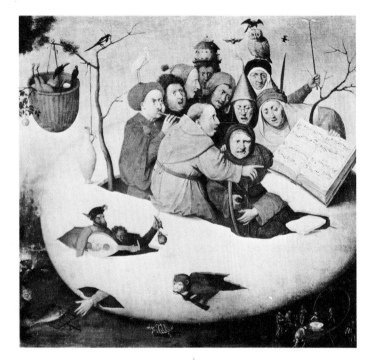

Concert in an Egg (after Bosch). *Musée des Beaux-Arts, Lille.*
(See colour reproduction p. 41)

Concert in an Egg. *Kupferstichkabinett, Berlin.*
Pen and bistre, 25.7 cm. x 17.5 cm. (10" x 6¾"). Catalogue No. 5 verso.
A sketch for a painting which is lost but is known from copies. On the reverse: *The Temptation of St. Anthony in a Landscape.*

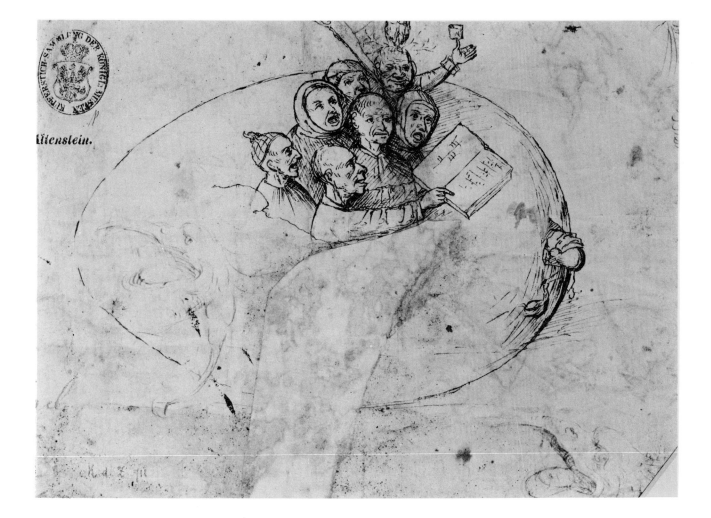

A Beggar and Various Sketches. *Kupferstichkabinett, Berlin.*
Pen and bistre, 20.3 cm. x 12.6 cm. (8" x 5"). Catalogue No. 6 verso.
Only the sick beggar is by Bosch. All the rest, in lighter ink, seem to be by a
pupil. On the reverse: *The Hearing Forest and the Seeing Field.*

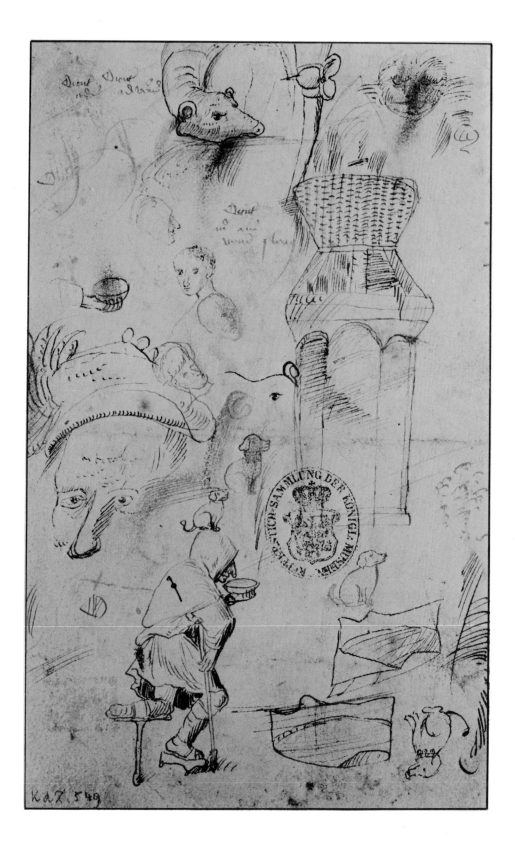

25

The Hearing Forest and the Seeing Field. *Kupferstichkabinett, Berlin.*
Pen and bistre, 20.3 cm. x 12. 6 cm. (8" x 5"). Catalogue No. 6.
Inscription in Gothic by a later hand: *Miserrimi quippe est ingenii semper*
uti inventis et nunquam inveniendis. The key to this enigmatic represent-
ation was provided by a woodcut of an anonymous Netherlandish Master,
dated 1546 and reproduced in *Nederlandsche Houtsneden, 1500-1550,*
depicting the same subject, with the following legend: *Dat veldt heft ogen,*
dat wolt heft oren, ick wil sien, swijghen ende hooren. (The field has eyes,
the forest has ears, I want to see, be silent and hear). On the reverse: *A*
Beggar and Various Sketches.

26

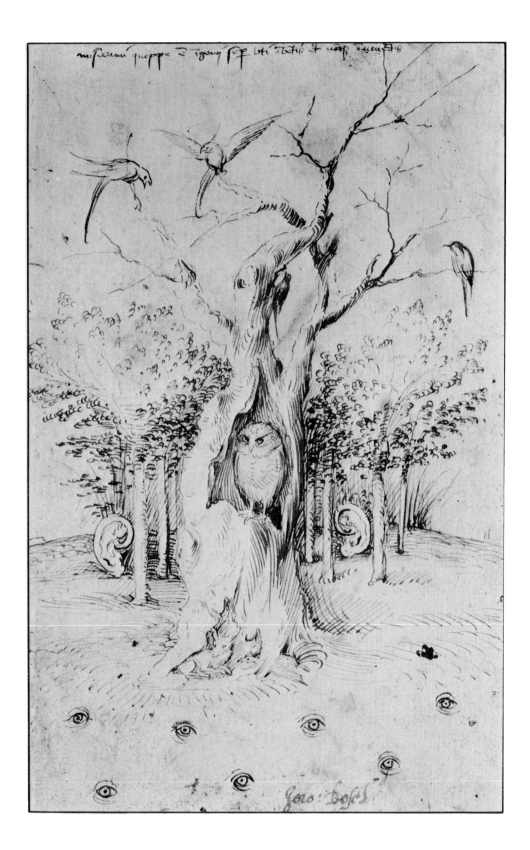

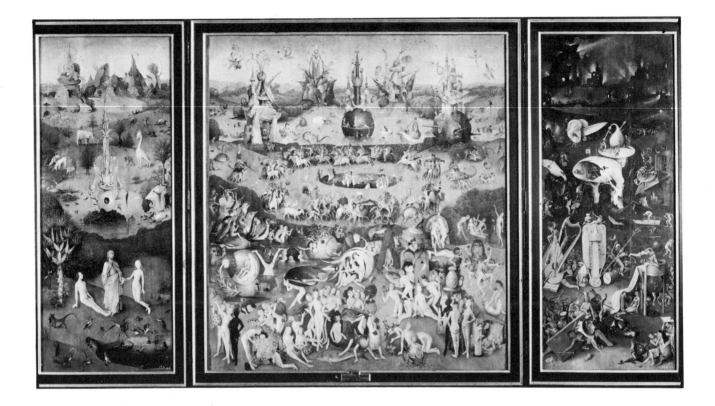

The Garden of Earthly Delights. *Museo del Prado, Madrid.*
Oil on wood. Centre panel: 220 cm. x 195 cm. (86½" x 76½"). Wings: 220 cm. x 97 cm. (86½" x 38").

The Tree Man. *Albertina, Vienna.*
Pen and bistre, 27.7 cm. x 21.1 cm. (10¾" x 8¼"). Catalogue No. 7.
The central figure anticipates the main motif of the *Hell* panel of the *Garden of Earthly Delights*. A weak paraphrase can be found in the drawing *Scene in Hell.*

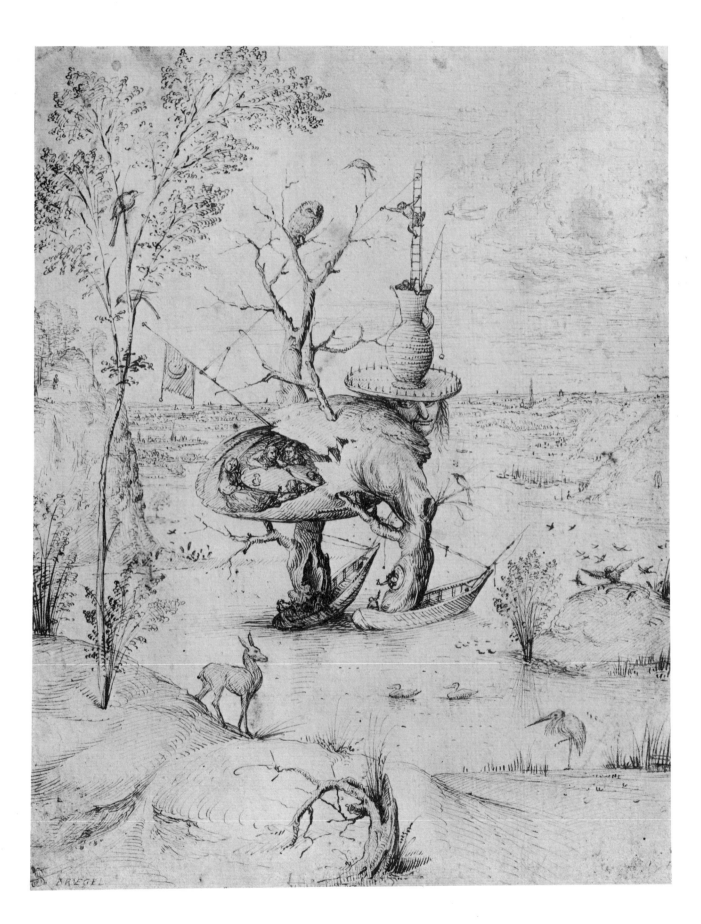

Owl's Nest on a Branch. *Museum Boymans-van Beuningen, Rotterdam.*
Pen and bistre, 5½" x 7¾" (14.0 cm. x 19.6 cm.). Catalogue No. 8.
The owl motif occurs regularly in Bosch's painting and drawings. It is
thought to be a personification of sin, more specifically of envy and hatred.

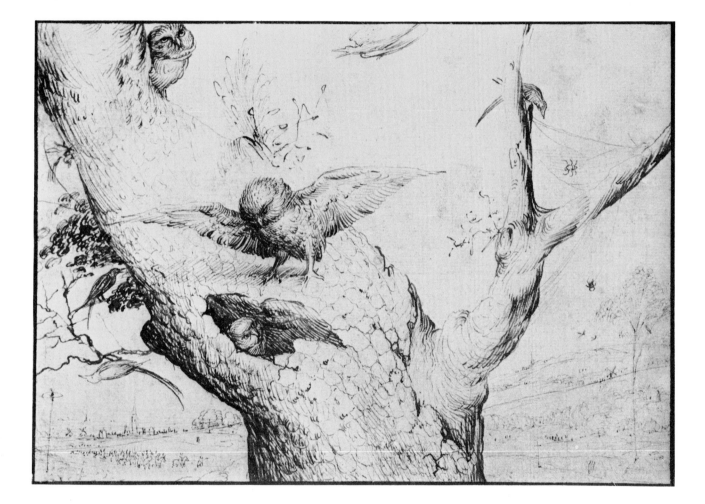

The Temptation of Eve by the Serpent. *Present owner not known.*
Pen and bistre, 15 cm. x 10.3 cm. (6" x 4"). Catalogue No. 8b.
This drawing may have been the first version of a scene on the left wing of
The Garden of Earthly Delights. On the reverse: *Two Caricatured Heads.*

Two Caricatured Heads. *Present owner not known.*
Pen and bistre, 15 cm. x 10.3 cm. (6" x 4"). Catalogue No. 8a.
This is the only sheet with studies of faces that is known to be by Bosch.
On the reverse: *The Temptation of Eve by the Serpent.*

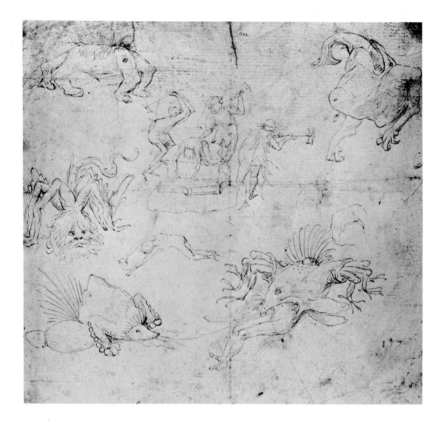

Scenes in Hell. *Kupferstichkabinett, Berlin.*
Pen and bistre, 15.6 cm. x 17.6 cm. (6" x 6¾"). Catalogue No. 9.
These drawings belong to the same period as the sheet of sketches in The Ashmolean Museum, Oxford, and are related to the fragment of *The Last Judgement* in Munich. On the reverse: *Monsters.*

Monsters. *Kupferstichkabinett, Berlin.*
Pen and bistre, 15.6 cm. x 17.6 cm. (6" x 6¾"). Catalogue No. 9 verso.
On the reverse: *Scenes in Hell.*

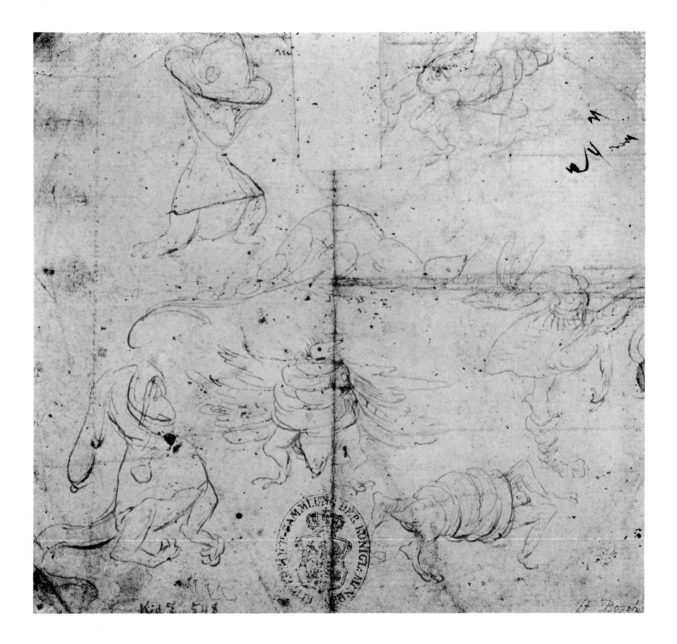

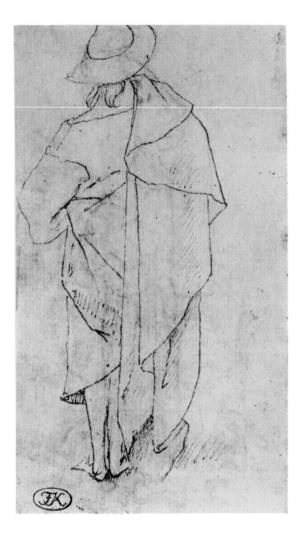

A Man Standing. *Museum Boymans-van Beuningen, Rotterdam.*
Black pencil and pen, 13.0 cm. x 8.4 cm. (5" x 3¼"). Catalogue No. 10a.
Whether or not Bosch was the author of this drawing remains an open question, it has been attributed to Pieter Bruegel the Elder.

Beggars and Cripples. *Bibliothèque Royale Albert I er (Cabinet des Estampes), Brussels.*
Pen and bistre, 26.4 cm. x 19.8 cm. (10½" x 7¾"). Catalogue No. 10.
This sheet of sketches was formerly attributed to Pieter Bruegel the Elder, but is now definitively recognized to be by Bosch. The signature and date 'Bruegel 1558' are apocryphal.

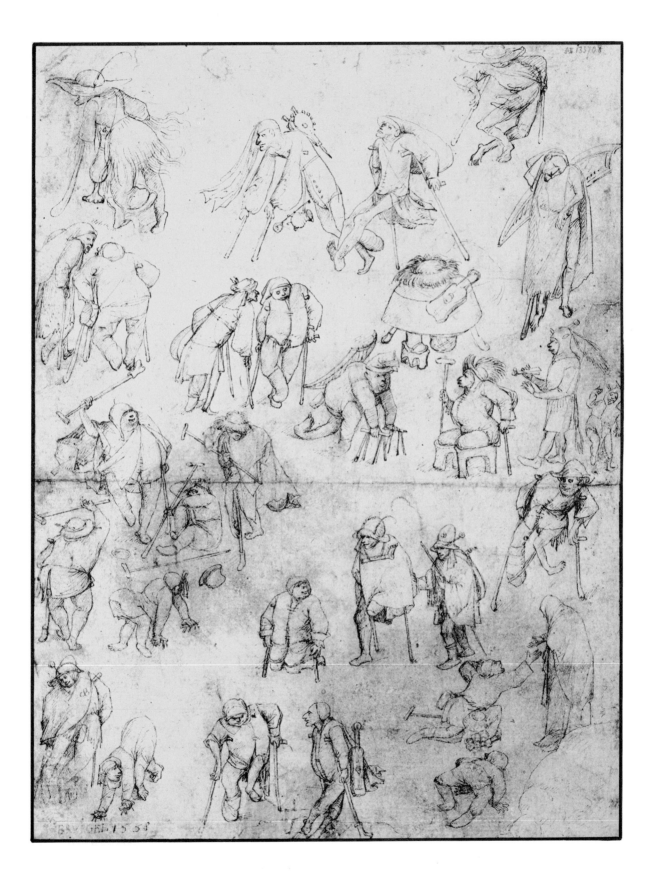

Monstrous Animals. *Musée du Louvre, Paris.*
Pen and bistre, 20.5 cm. x 26.3 cm.(8" x 10½"). Catalogue No. 11 verso.
On the reverse: *The Temptation of St. Anthony.*

The Temptation of St. Anthony. *Musée du Louvre, Paris.*
Pen and bistre, 20.5 cm. x 26.3 cm. (8" x 10½"). Catalogue No. 11.
Bosch was fascinated by the life of St. Anthony, to whom he dedicated
several paintings. As in the Berlin drawing, this sheet contains several studies
on the same theme. On the reverse: *Monstrous Animals.*

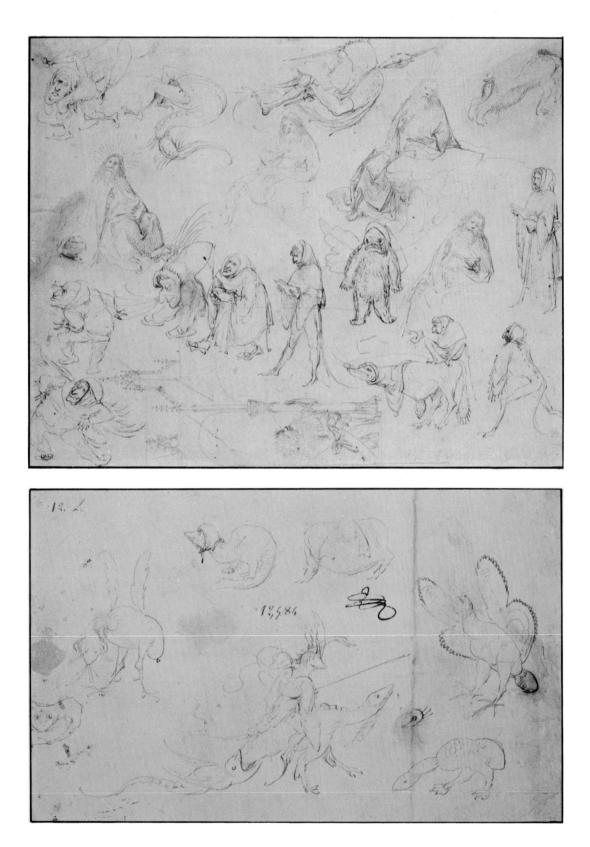

39

COLOUR PLATES

Concert in an Egg (after Bosch). *Musée des Beaux-Arts, Lille.*
Unsigned. Oil on canvas. 107 cm. x 125 cm. (42" x 49¼").
The drawing in Berlin is a preliminary study for the painting. The original *Concert in an Egg* by Bosch's hand was lost but there are two copies known. The other copy is in the Roland Barny d'Avincourt Collection in Paris, formerly Pontalba de Senlis Collection, Paris.

The Ship of Fools. *Musée du Louvre, Paris.*
Unsigned. Oil on wood. 57.8 cm. x 32.5 cm. (22¾" x 12½").
It is possible that this painting was a wing of a diptych or triptych, whose other panels may have represented other Ships of Fools. Bosch's sketch in the Akademie der Bildenden Künste, Vienna may have been a study for the right wing. The painting in the Louvre would then represent the fool's paradise, the Vienna drawing the fool's hell.

The Tree Man. *Museo del Prado, Madrid.*
Unsigned. Oil on wood. 220 cm. x 97 cm. (86½" x 38¼").
The Tree Man, formerly in the Escorial, forms the right wing of the triptych *The Garden of Earthly Delights.* The main figure is anticipated in the drawing in the Albertina, Vienna, and a weak paraphrase can be found in the sheet of sketches *Scene in Hell,* in Dresden.

The Last Judgement (fragment). *Alte Pinakothek, Munich.*
Unsigned. Oil on wood, 60 cm. x 114 cm. (23½" x 45").
The devil seen from the rear, right, and the monster below him are both anticipated in the sheet of sketches with monsters in The Ashmolean Museum, Oxford.

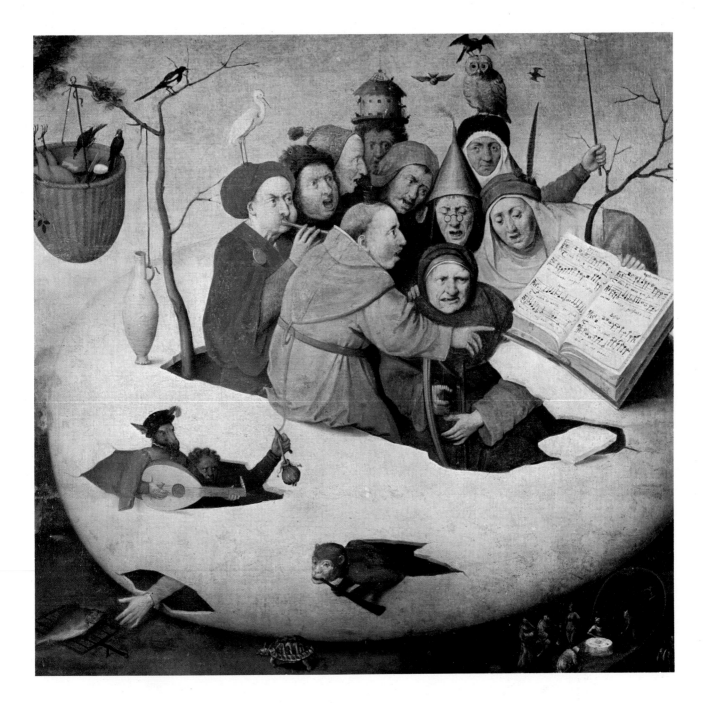

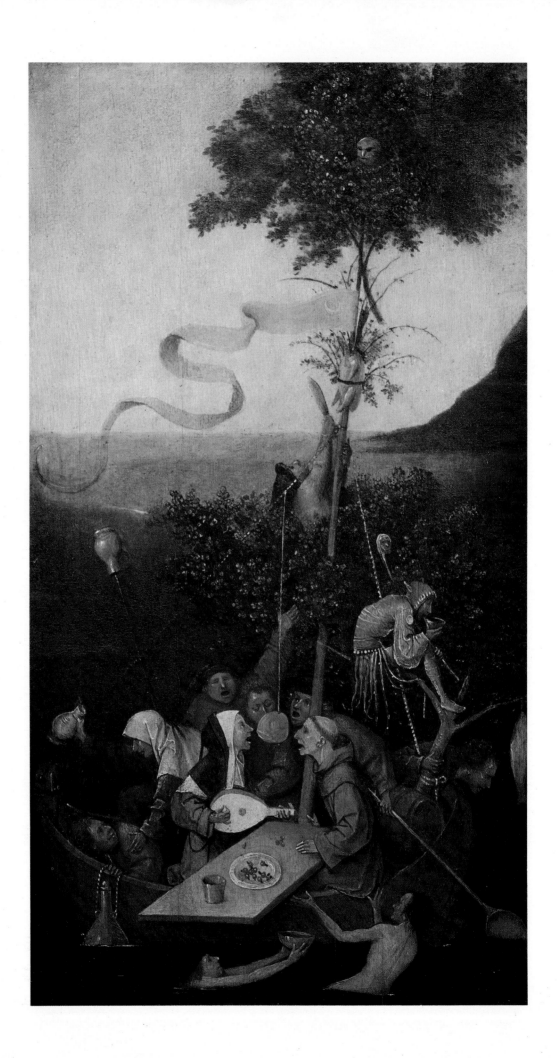

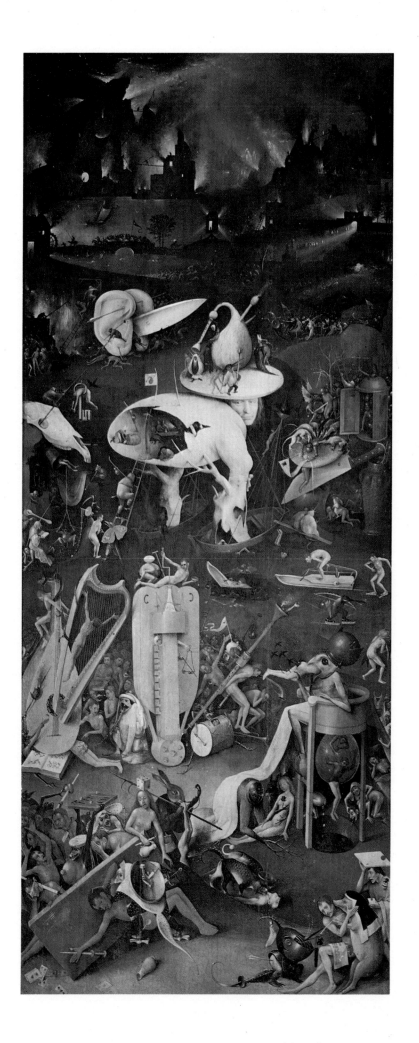

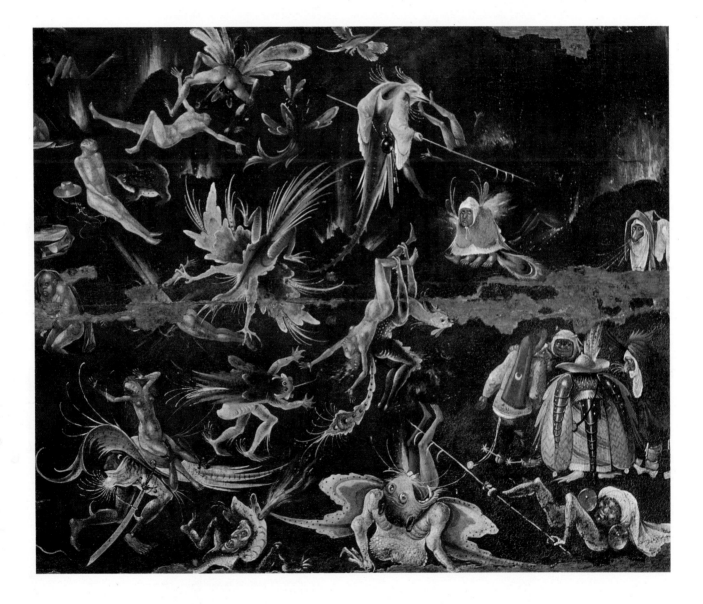

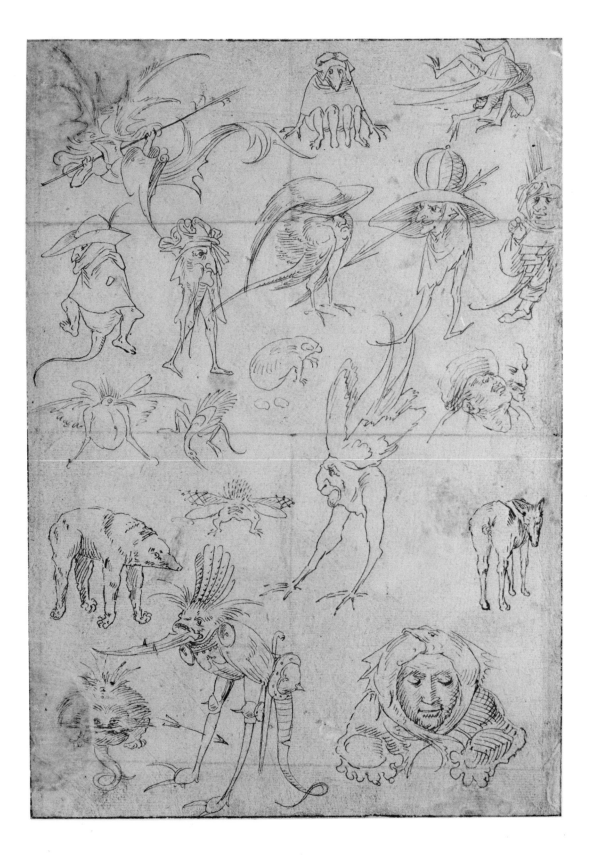

Studies of Monsters. *Ashmolean Museum, Oxford.*
Pen and bistre, 31.8 cm. x 21 cm. (12½" x 8¼"). Catalogue No. 12 verso.
On the reverse: *Monsters.*

Monsters. *Ashmolean Museum, Oxford.*
Pen and bistre, 31.8 cm. x 21 cm. (12½" x 8¼"). Catalogue No. 12.
Two of these sketches served as the models for two monsters in the Munich
fragment of *The Last Judgement.* On the reverse: *Studies of Monsters.*

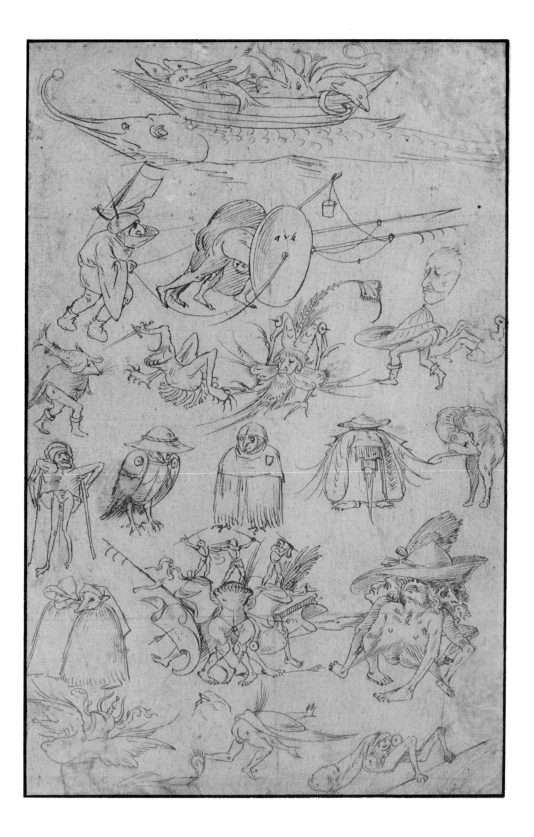

Beggars. *Albertina, Vienna.*
Pen and bistre, 28.5 cm. x 20.5 cm. (11" x 8"). Catalogue No. 13.
Although many scholars formerly attributed these sketches to Pieter Bruegel the Elder, they have now been definitively assigned to Bosch's first period.

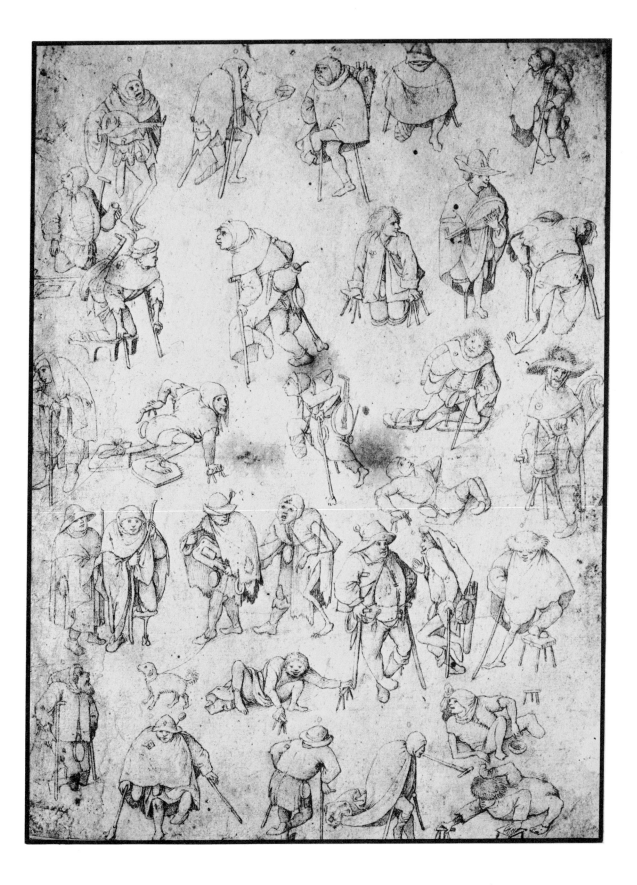

49

Sheet with a Rider above and Studies for Three figures below, for a Golgotha composition. *Present owner not known.*
Pen and ink. Catalogue No. 14a.
Not illustrated here.

Witches. *Musée du Louvre, Paris.*
Pen and bistre, 20.3 cm x 26.4 cm. (8" x 10¾"). Catalogue No. 14.
Bruegel knew this drawing and used it for the main scene in his *Battle between Carnival and Lent.* The inscription 'Bruegel manu propria' was added later.

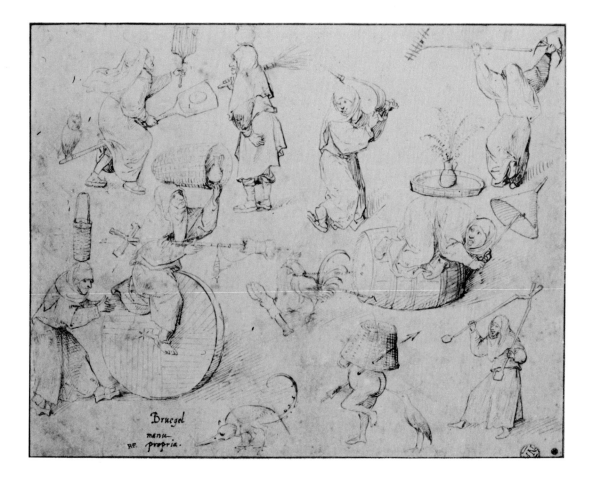

Beehive and Witches. *Albertina, Vienna.*
Pen and bistre, 19.2 cm. x 25 cm. (7½" x 10¾"). Catalogue No. 15.
Bosch used the motif of the man in the beehive to decorate the throne on
the centre panel of *The Altarpiece of the Hermits* in the Palace of the Doges,
Venice. On the reverse: *Witches.*

Witches. *Albertina, Vienna.*
Pen and bistre, 19.2 cm. x 25 cm. (7½" x 10¾"). Catalogue No. 15 verso.
On the reverse: *Beehive and Witches.*

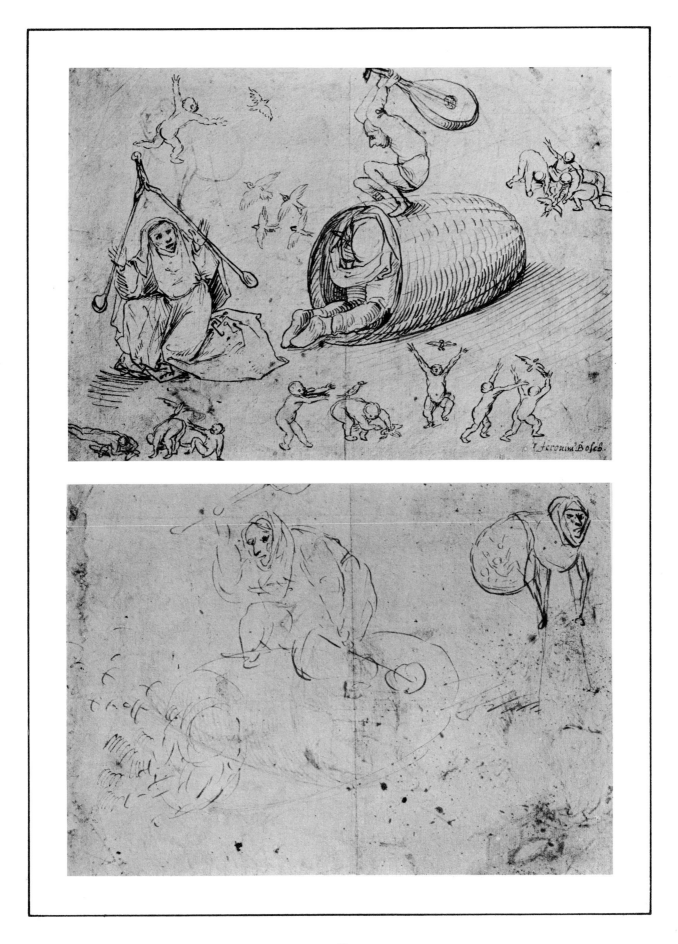

Animal Studies. *Kupferstichkabinett, Berlin.*
Pen and ink, 8.5 cm. x 18.2. cm. (3½" x 7¼"). Catalogue No. 16.
The toad-like monster, lower right, was used on the reverse of *Flood and Hell.* On the reverse: *Two Monsters.*

Two Monsters. *Kupferstichkabinett, Berlin.*
Pen and ink, 8.5 cm. x 18.2 cm. (3½" x 7¼"). Catalogue No. 16 verso.
On the reverse: *Animal Studies.*

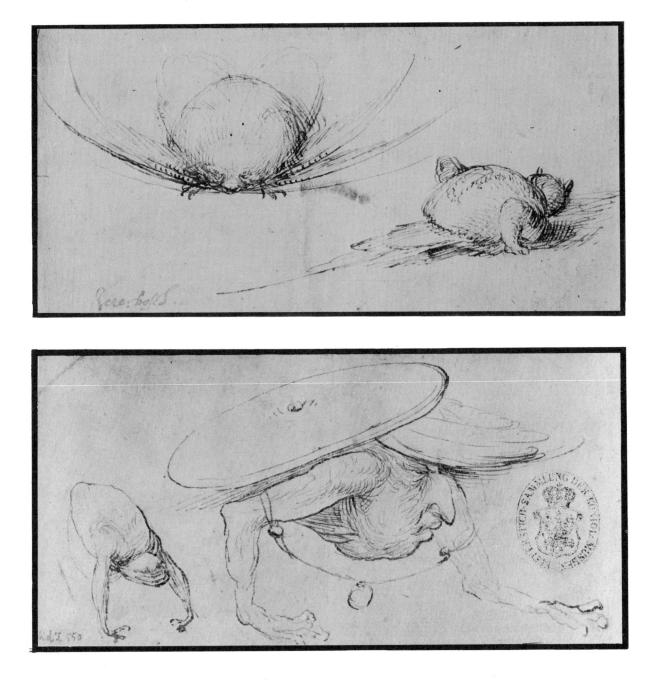

Tortoise with Death's Head on its Carapace and Winged Demon. *Kupfer-stichkabinett, Berlin.*
Pen and bistre, 16.4 cm. x 11.6 cm. (6½" x 4½"). Catalogue No. 17 verso.
Later signature in bistre. On the reverse: *Two Monsters.*

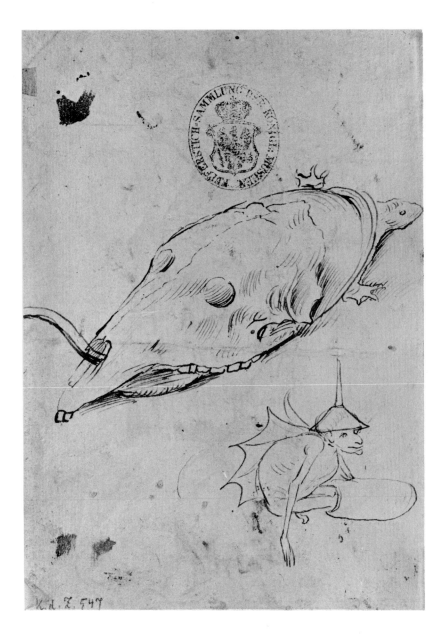

Two Monsters. *Kupferstichkabinett, Berlin.*
Pen and bistre, 16.4 cm. x 11.6 cm. (6½" x 4½"). Catalogue No. 17.
On the reverse: *Tortoise with Death's Head on its Carapace* and *Winged Demon.*

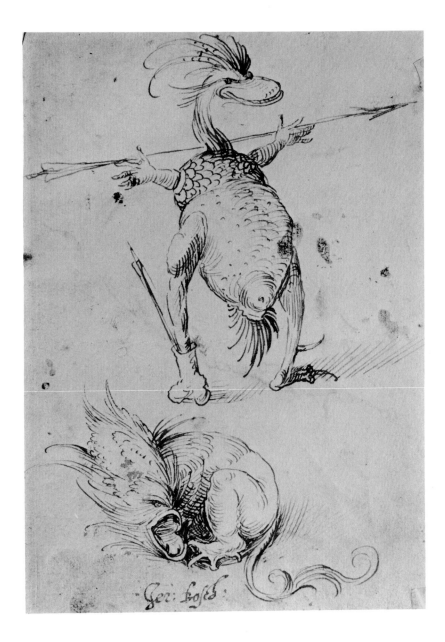

Mary and John at the Foot of the Cross. *Kupferstichkabinett, Berlin.*
Brush, 30.2 cm. x 17.2 cm. (12" x 6¾"), trimmed round at the top.
Catalogue No. 18a.
Later inscription 'Hieronymus Bosch', but probably not by Bosch. On
the reverse: *Holy Woman at the Grave.*

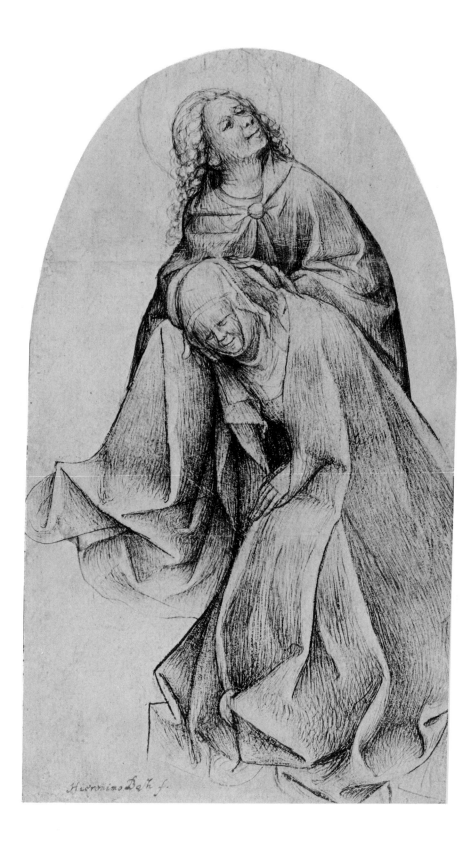

Holy Woman at the Grave. *Kupferstichkabinett, Dresden.*
Brush, 30.2 cm. x 17.2 cm. (12" x 6¾"). Catalogue No. 18b.
On the reverse: *Mary and John at the Foot of the Cross.*

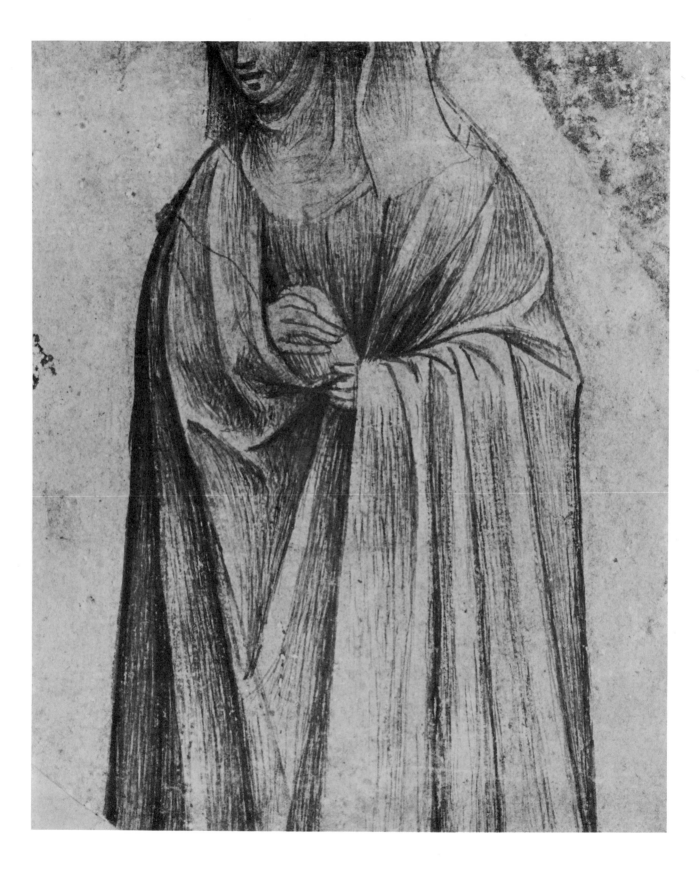

Standing Rabbi or High Priest. *Kupferstichkabinett, Dresden.*
Pen, 19.7 cm x 27.7 cm. (7¾" x 11"). Catalogue No. 18c.
Later inscription 'H. Bosch', but probably not by Bosch. On the reverse:
Scene in Hell.

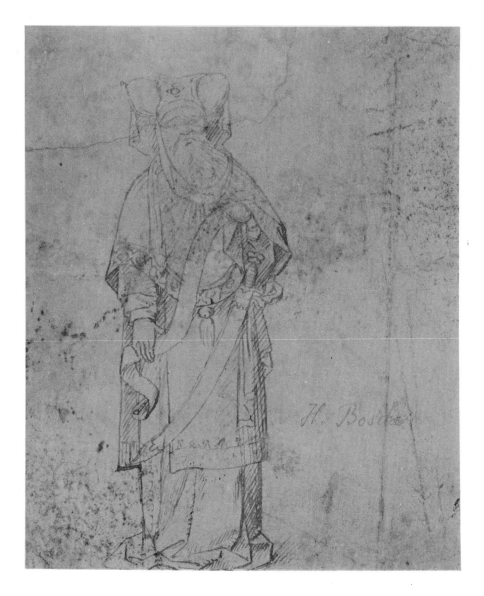

Scene in Hell. *Kupferstichkabinett, Dresden.*
Pen, 19.7 cm. x 27.7 cm. (7¾" x 11"). Catalogue No. 18d.
A paraphrase of the right wing of *The Garden of Earthly Delights,* probably not
by Bosch. On the reverse: *Standing Rabbi or High Priest.*

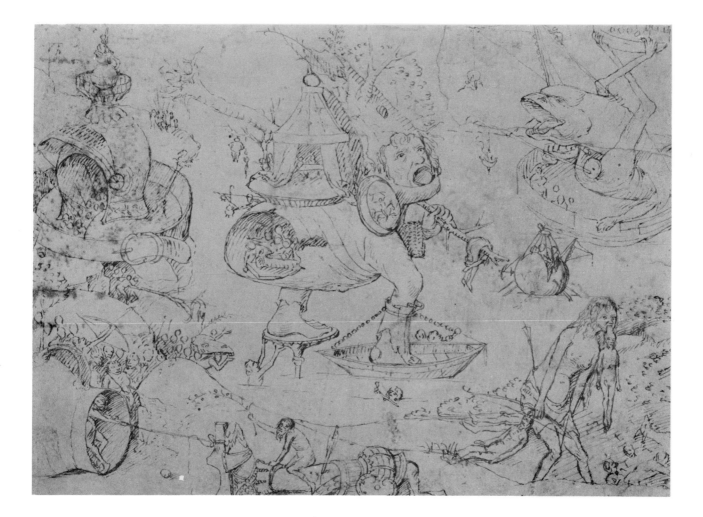

A Man Emptying a Trough. *Musée du Louvre, Paris.*
Pen, 14.3 cm. x 9.5 cm. (5½" x 3½"). Catalogue No. 19.
Possibly an illustration of a proverb, dating from the end of Bosch's middle
period.

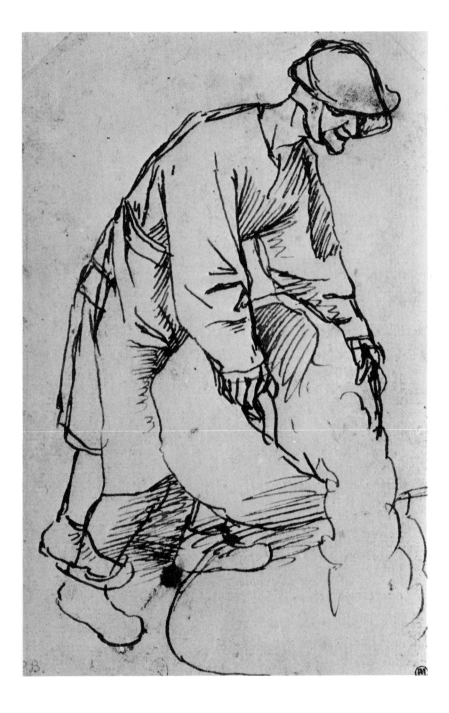

Christ Carrying the Cross. *Museum Boymans-van Beuningen, Rotterdam.*
Pen, 9¼" x 7¾" (23.6 cm. x 19.8. cm.). Catalogue No. 20.
Attribution uncertain.

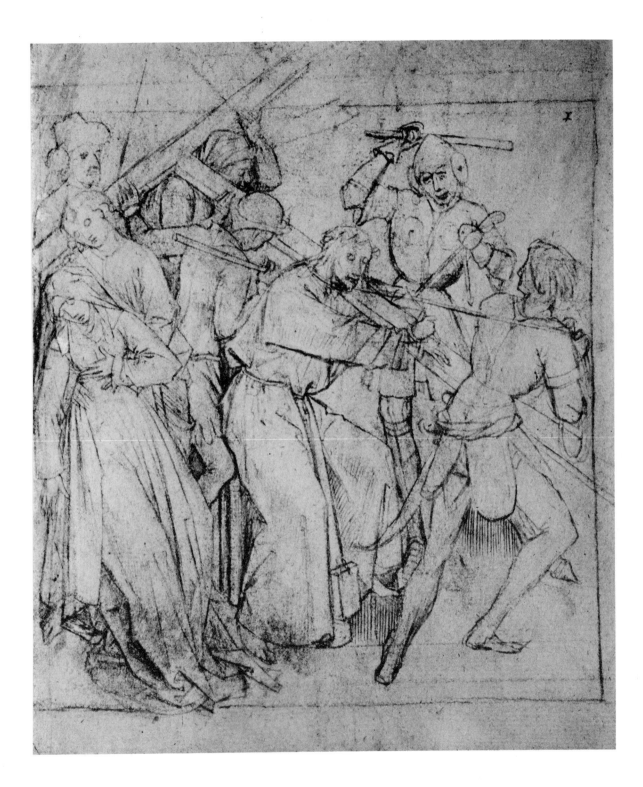

Sheet of Sketches with Heads. *Museum Boymans-van Beuningen, Rotterdam.*
Pen, 17.4 cm. x 11.8 cm. (7" x 4½"). Catalogue No. 21a.
Sometimes attributed to Allaart de Hameel. On the reverse: *A Warrior.*

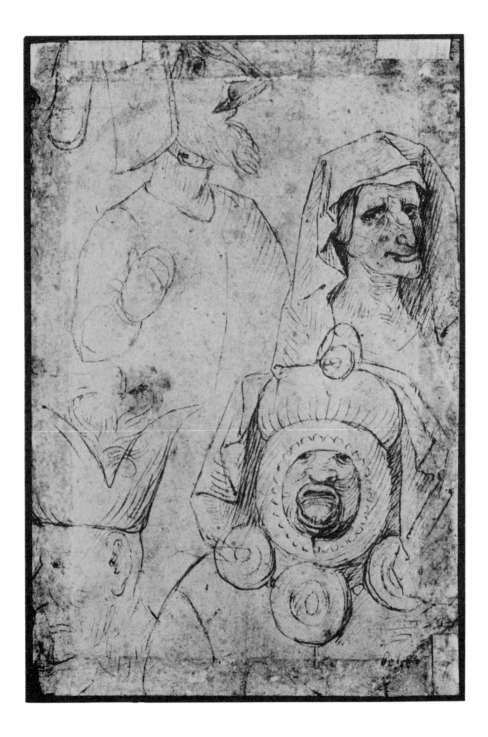

A Warrior. *Museum Boymans-van Beuningen, Rotterdam.*
Pen, 17.4 cm. x 11.8 cm. (7" x 4½"). Catalogue No. 21b.
Sometimes attributed to Allaart de Hameel. On the reverse: *Sheet of Sketches with Heads.*

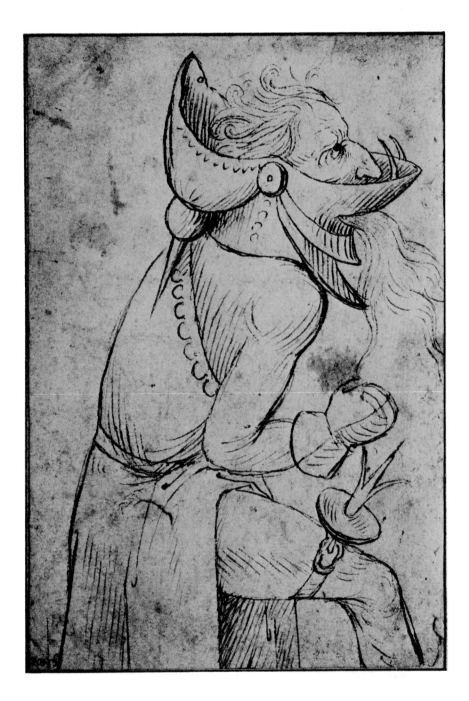

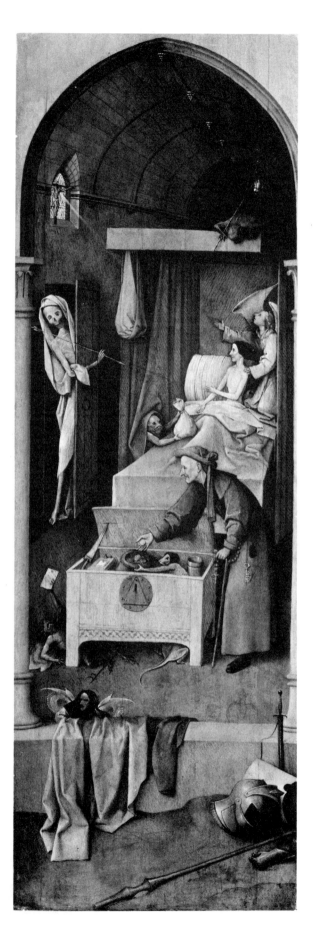

Death and the Miser. *Musée du Louvre, Paris.*
25.6 cm. x 14.9 cm. (10" x 5"). Catalogue No. 22
The drawing is a preliminary study for the painting.
On the reverse: *Various Sketches.*

Death and the Miser. *National Gallery of Art,
Washington D.C., Samuel H. Kress Collection.*
Unsigned. Oil on wood, 92.6 cm. x 30.8 cm.
(36½" x 12").

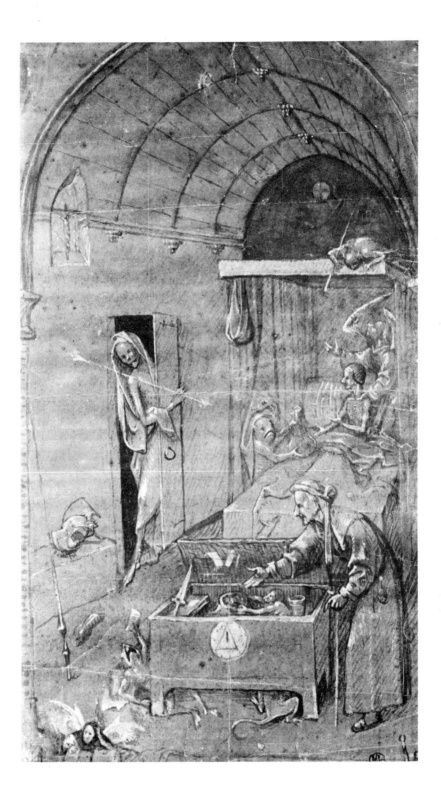

Various Sketches. *Musée du Louvre, Paris.*
25.6 cm. x 14.9 c. (10" x 5"). Catalogue No. 22 verso.
A helmet is featured on this sheet and a pen sketch of an animal,
apparently be a later hand, is pasted on the lower right corner.
Inscription in late Gothic script: 'Jeronimus Bos van Antwerpen'. On
the reverse: *Death and the Miser.*

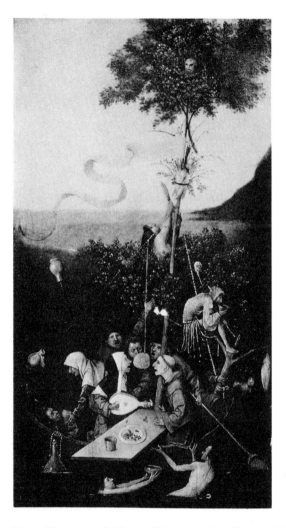

The Ship of Fools. *Musée du Louvre, Paris.*
(See colour reproduction p. 42).

Ecce Homo and Christ Carrying the Cross. *Crocker Art Gallery, Sacramento, California.*
Pen and bistre, worked over in pencil by a later hand. 25.4 cm. x 20.1 cm. (10" x 8"). Catalogue No. 24.
This drawing is generally attributed to Allaart de Hameel. *Not illustrated here.*

The Ship of Fools. *Musée du Louvre, Paris.*
Grisaille, 25.7 cm. x 16.9 cm. (1o" x 6½"). Catalogue No. 23.
It is not certain if this drawing was made as a preliminary study for *The Ship of Fools* or if Bosch
sketched it after the painting was completed.

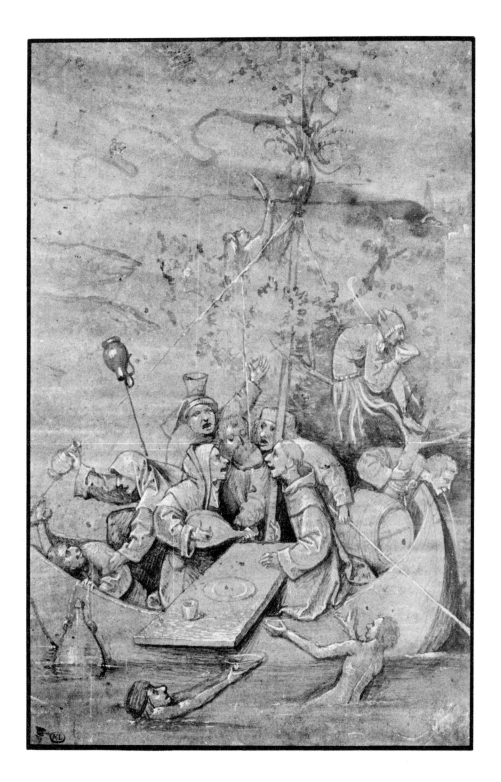

The Last Judgement. *British Museum, London.*
24 cm. x 34.6 cm. (9½" x 13½").
Engraved copy by Allaart de Hameel of a lost original by Bosch.

A Beleagured Elephant. *British Museum, London.*
20.4 cm. x 33.5 cm. (8" x 13¼").
Engraved copy by Allaart de Hameel of a lost work by Bosch. The
inventory of the Royal Palace in Madrid drawn up after the death
of Philip II mentions a painting of the same subject.

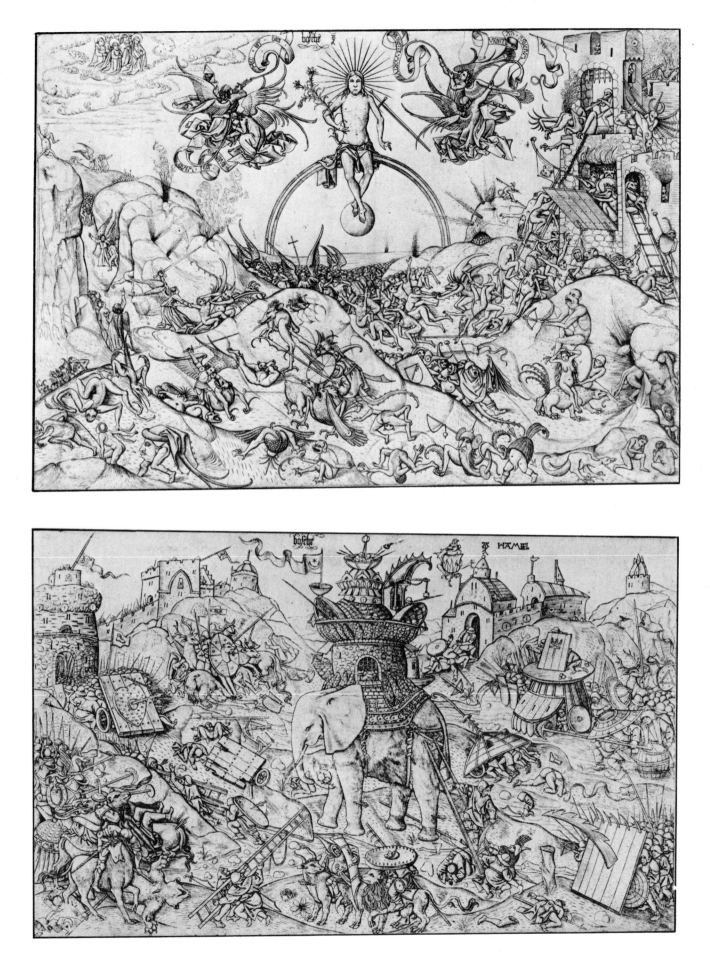